D0062031

FABULOUS FICTIONS
AND PECULIAR PRACTICES

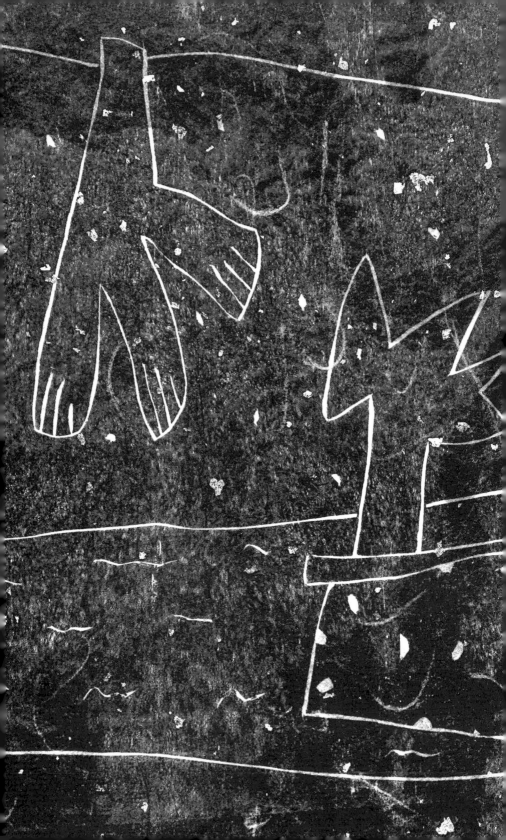

Fabulous

FICTIONS

& PECULIAR
practices

LEON ROOKE'S NARRATIVES
PRESENTED HEREWITH
ARE BASED ON FIGMENTS
OF TONY CALZETTA'S
GRAPHIC IMAGINATION

The Porcupine's Quill

Library and Archives Canada Cataloguing in Publication

Rooke, Leon, author
 Fabulous fictions & peculiar practices : Leon Rooke's narratives
presented herewith are based on figments of Tony Calzetta's graphic
imagination.

ISBN 978-0-88984-393-6 (paperback)

 I. Calzetta, Tony, 1945–, artist II. Title. III. Title: Fabulous fictions
and peculiar practices.

PS8585.064F32 2016 c813'.6 c2016-900741-3

Published by The Porcupine's Quill, 68 Main Street, PO Box 160,
Erin, Ontario NOB 1TO. http://porcupinesquill.ca

Represented in Canada by the Canadian Manda Group.
Trade orders are available from University of Toronto Press.

We acknowledge the support of the Ontario Arts Council and the
Canada Council for the Arts for our publishing program.
The financial support of the Ontario Media Development Corporation
and the Canada Book Fund is also gratefully acknowledged.

FABULOUS FICTIONS

PECULIAR PRACTICES

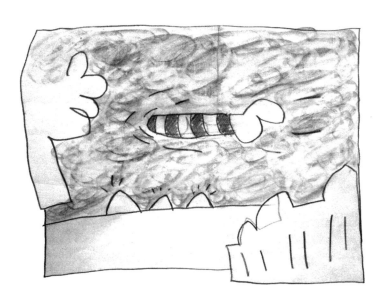

HOW GOD TALKS IN HIS SLEEP
AND OTHER FABULOUS FICTIONS

PRODUCTION NOTES

The 'Fabulous Fictions' project began with an uncommon idea. Artist Tony Calzetta and his printmaker friend Dieter Grund at Presswerk Editions were looking for a project they could work on together. Tony suggested they collaborate with Governor-General's Award–winning novelist Leon Rooke to produce a limited edition *livre d'artiste*. One twist to the project was that, instead of the customary practice of the artist illustrating the writer's text, they would approach the Fabulous Fictions project the other way round.

Tony presented Leon with a number of small drawings. Leon wrote sketches for nineteen of the images, which artist and author then winnowed down to a select nine 'Fabulous Fictions'. Tony reworked the original drawings and combined them with Leon's texts and media that included intaglio, woodcut and digital printing. In addition, one of the drawings and its text, 'How God Talks in His Sleep', was reimagined as an interactive paper sculpture and attached to the front of the slipcase. The ten 'outtakes' were published as a series of broadsides entitled 'Peculiar Practices'. Forty-five copies of the matched set were painstakingly produced with the assistance of master bookbinder Keith Felton; each of them retailed for a breathtaking sum which came nowhere close to compensating any of the participants for their rampant enthusiasm.

One thing led to another. Tony presented his artist's book to publisher Tim Inkster, who subsequently shared his convictions with curator Tom Smart. Tom was quick to recognize the dramatic possibilities inherent in the work and enlisted the support of dramaturge David Ferry. The timely availability of the Canada Council's Strategic Markets Initiative was critical to the development of a ten-minute staged theatrical version of 'Cézanne's Muse' that appeared as part of Marc Glassman's Pages UnBound festival at the Randolph theatre in May of 2015, a cabaret-style production that featured sixteen students from the Randolph Academy for the Performing Arts under the direction of David Ferry.

By that time (spring 2015) Tom Smart had written an extensive retrospective on Tony's career that appeared first as a feature in the *Devil's Artisan* 76 and was subsequently re-released by the Porcupine's Quill as a monograph called *Fabulous Peculiarities*. An ambitious funding application to the Ontario Media Development Corporation to expand the theatrical production to encompass the whole of the work was unsuccessful, but Tom Smart was able to secure support for a gallery exhibition of Fabulous Fictions that will open at the Peel Art Gallery, Museum and Archives in April 2016, at which time we will launch this popularly priced trade edition in book form.

—The Publisher

WORD PICTURES:
THE RICH COLLABORATION
BETWEEN LEON ROOKE
AND TONY CALZETTA

The idea that god talks in his sleep is an entrancing notion. To be truthful, I had never entertained the possibility. For that matter, I'm not sure I even thought he slept. I know the story about him resting after the Six Days of Creation, but the idea of the supine stretch of his body, eyes closed, and maybe an embarrassing noise escaping from his mouth, never entered my mind. Since we know that he knows everything we think, and he sees everything we do, it occurred to me that sleep could get in the way of that omnivorous knowledge. And he wouldn't have to worry about sleep deprivation because ... well, he's god. But Leon Rooke's title got me thinking about what god does say in his sleep; does he cry out his sympathetic pain and frustration at the way his creation has gone awry; does he whisper the name of his secret inamorata; does he babble in his dreaming of dreams?

These are, of course, speculations fuelled by the rich suggestion of Leon Rooke's naming, of his own god-playing in the world that he and Tony Calzetta have created. To be sure, there are readable clues as to the kind of guy god is and my advice would be not to cross him. In the opening story, which Calzetta has realized in the form of a foldout book sculpture, he comes across as an extortionist, subtly reminding us that tithing twice as much as expected just might help us avoid walking into open

graves. He's also quite prepared to leave the status quo as it is, rendering those who are without still without. This god is heavily into cost reduction and profit maximization, no matter the price. He acts like a capricious finance minister, and dreams like a gangster.

God brackets the book; if he's a somnambulant enforcer in the beginning, near the end he's a lech, the hoary old leader of a group of confused disciples, chasing after a young girl and insinuating that he might withhold immortality if his physical needs are not administered to. He is also a prankster: when he can't turn tricks with an innocent, he will play tricks on his unsuspecting creation. We are his flies and he is a wanton adult boy who has refused to grow up. He most certainly uses us for his sport.

I'm pleased to say that Leon Rooke and Tony Calzetta do too, in the most delightfully intelligent way. Their collaboration was made with heaven and hell equally in mind; it is full of madnesses and deceptions, serendipities and generosities; it smells of sulphur and vanilla. (Did I mention that it exudes the brightness of Mondrian's palette?) It is riddled with foibles and rampant with *felix culpa*s. It is worth saying, over and over again, that their having worked together was a most fortunate fall into the world of the livre d'artiste.

I think of Rooke and Calzetta as the Brother Grim and the Brother Grin. In their drawn and written incarnations, these fabulous fictions put on the degree of perversity and exuberance necessary to their telling. They are full of knowing innocence and an elusive jouissance. They occupy the terrain of the fairy tale, the allegory and the folk tale, all literary forms of deceptive simplicity.

The collaboration was a tidy one; Calzetta's drawings were, at his own admission, 'preparatory sketches', notes to himself that simply delineated ideas for larger paintings—a shape might suggest a rock or a tree, a few undulating lines could be water, mountains, or the tracing of an uncertain sky. For Rooke's part, the drawings would usually say something to him from the outset. 'There was the immediate suggestion and then I seemed to have found a rhythm that made it very easy to create the story around the drawings, to extend them and make forays into the hinterlands.'

Oftentimes, that hinterland exploration engaged a single image that Rooke would put to unusual purposes. A floating striped shape becomes the hand of god in the title story; in the next story a pair of pillars reminds him of bank architecture, wherein an overblown and cynical bank president addresses his minions; a shape with four points hovers above a prickly landscape and is transformed into the 'four-tittied bitch of a Scots girl' who is 'gallopeding on a grey pony around and around the castle walls'. In this story, Ms Smith attempts to explain to her husband why she has spent the night in the nightgown of another man. The explanation has something to do with being 'among our olives', her admirably economical euphemism for the consumption of prodigious numbers of gin martinis.

This narrative is a perfect example of the improbable connections Rooke makes once his story starts rolling; you hear in Ms Smith a character who could congenially inhabit a comic version of a Robert Browning dramatic monologue; the Scots girl is an ethnic variation on Lady Godiva; and Rooke discovers the wonderful word 'gallopeding', which initially he thought he had invented, in the letters of Virginia Woolf. It is a word he

employs to his heart's content. To borrow a phrase from another writer who gave language a run for its money, there are more things here than are dreamt of in most philosophies. 'It's the way language works', Rooke says, 'it suggests a story in the odd tumble of words.'

Let me offer a more complete example of how he springboards into narrative from the simple drawings that Calzetta has made available. At the outset, it is important to realize that Tony's style of drawing is not in any way unknowing; the simplicity of his line and shape occupy a tradition that includes the quirky edginess of late Philip Guston, the nervous vibrations of Keith Haring, and the overall casualness of the cartoon. In the drawing for *The Scroll of Civilization* (I am providing only the abbreviated title), Calzetta sets a tubelike shape across a shaft that rises up from the water. It could be a thimble; it could be a finger; it could be just a form. This is a world governed by Could-be. So the central object is a piece of architecture; it is a sculptural object; it is an instrument of maritime navigation.

What Rooke does is layer meanings onto the horizontal shape: in his telling it is the scroll of civilization, transformed initially into a rusted periscope and then into a metonymic ship, the periscope of which allows us to see land and to discover a safe navigation. What the scroll carries is itself, the inscribed representation of civilization, which is transported to the uninhabited isle. This is the story of *The Tempest* and *Atlantis* rolled into one discursive fragment developed from a single, uncomplicated drawing. The story itself is a fable, an elaborate narrative of society's indifference to the artist. *The Scroll of Civilization* is full of fine conceits and pleasing literary contours. The name of the painter is Exubrio; his wife (herself a sculptor whose art is

reviled and who is reduced to cleaning toilet bowls) is called Denuncia Francesca Illuminati Luminesa. Her naming is a splendid redundancy; self-consciously overripe, commensurate with the story she inhabits. She is drugged to prevent her from attacking her stubborn husband who has decided to throw his life's work into the sea. The story has a courtly frame with a decidedly contemporary twist and an economical sense of the colloquial. (Their daughter, the lovely Cherise, has been punching her dearest friends 'in the chops' as an angry response to her parents' lack of recognition.) In the midst of this hand-wringing and domestic melodrama, we get the elegant line as the sleeping potion embraces the potentially murderous Denuncia. The potion 'compelled her pulse at that moment to slow, her head to nod, her breath to leap as a gazelle summoned to lazy dream.' Rooke channels Andrew Marvell and faintly complains on the little death of his own fawn-like creature.

Calzetta came to appreciate that it would be difficult to do illustrations for Rooke's writing. 'I thought it would work better the opposite way because I knew he liked my work and that he would have fun with it.' When he read the stories Rooke had written in response to his drawings (they were 'quite strange') he realized the initial collaboration he'd had in mind wasn't going to do justice to the text. As Rooke had done in the writing, Calzetta began sampling his own repertoire of influences. He looked to a Whitney Museum catalogue of Red Grooms's work from the 1970s; he lifted the pure colour scheme that Jim Dine had used in designing the catalogue raisonné for his photographic work (the four-volume set published by Steidl in 2003 was called *The Photographs, So Far*); he scrutinized pop-up books. The project began to generate its own sense of complexity. 'It definitely had a mind of its own', he recalls. 'At one point I

couldn't get a handle on it, it just kept changing. It was like being in a car and not being able to steer it.'

Calzetta stayed in the driver's seat and now the vehicle hums along. He also changed roles inside the process, moving from driver to engineer and mechanic. He began to rework his original drawings in response to Rooke's extrapolated readings. The title drawing is a revealing example of the reciprocal dialogue that has operated from word to image and not only from image to word. In the word-to-image exchange between writer and painter, Calzetta took the original pencil sketch for *How God Talks in His Sleep* and transformed it into a book sculpture which includes components from a number of the drawings and which locates the title drawing in the centre of the pop-up space. The sculpture's brilliant collage and origami form changes the simple graphite values of the sketch into a rich interplay of primary colours. At the top of the reworked drawing is the yellow-handed arm of god, sporting a black-and-white-striped pattern that Picasso could have worn on a Mediterranean beach, or that a convict could be wearing in jail. Given the character of the god we have encountered in the stories, the safest bet is on the latter. And if Picasso gets removed from the visual space, then Matisse finds his rightful spot in the radiant colours and lyrical shapes that Calzetta has orchestrated in this miniature cut-out world.

The collaboration between painter and writer comes together most forcefully in their shared theatricality. Rooke finds in Calzetta's work a predisposition towards the dramatic, and a defining structure that often takes the form of a proscenium stage. This tendency perfectly suits Rooke's own sense of theatre and the way he develops his characters. They write themselves into existence and they interact in accordance with the kind of

character they are. They are most apparent in the ravening beasts at fairy godfather house, a drawing in which a trio of sail-topped pillars (or dunce-like pillars—you can take your pick) seem to be doing a standup routine inside a space flanked by stage curtains. Calzetta draws the stage and Rooke gathers together the ensemble company to perform there. His cast is a clutch of the slandered and the exonerated, the latter group including buxom peasant girls and black musicians who have sold their souls, women who have kissed frogs, soufflé chefs, 'those who polish our steeples in the dead of winter', and 'my lover who warmly says goodnight to me every morning.' They're like figures from a reverse elimination dance and their play ends when the ravenous beasts venture into the nocturnal landscape, spurred on by the hissing of oleander bushes, the panting of mongrels and the sight of 'bleached skulls hanging from boughs bent by all that came before our society was formed.'

What a fabulous vision: dystopic, generative, monstrous and mutable. Leon Rooke and Tony Calzetta have made something unique inside the frame of their combined word pictures. They are at once director, actor, set designer, writer and painter. They have made the stage, and have given it form and language. As I say it, the whole enterprise sounds godly.

—Robert Enright

Robert Enright, Research Professor in Art Criticism at the University of Guelph, is one of Canada's most prominent cultural journalists. He founded and is currently the Senior Editor of *Border Crossings* magazine. He has received numerous nominations and medals at the National and Western Magazine Awards for his writing. In 2005 he was made a member of the Order of Canada.

FABULOUS FICTIONS

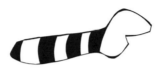

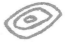

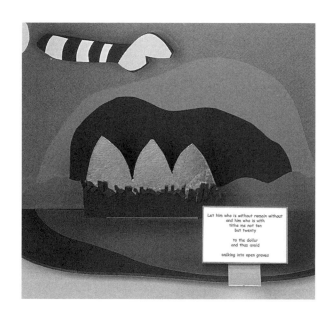

Let him who is without remain without
and him who is with
tithe me not ten
but twenty

to the dollar
and thus avoid

walking into open graves

HOW GOD TALKS IN HIS SLEEP

L et him who is without remain without

and him who is with

tithe me not ten

but twenty

to the dollar

and thus avoid

walking into open graves

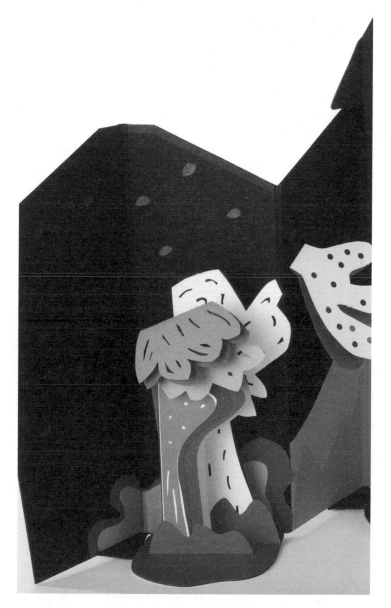

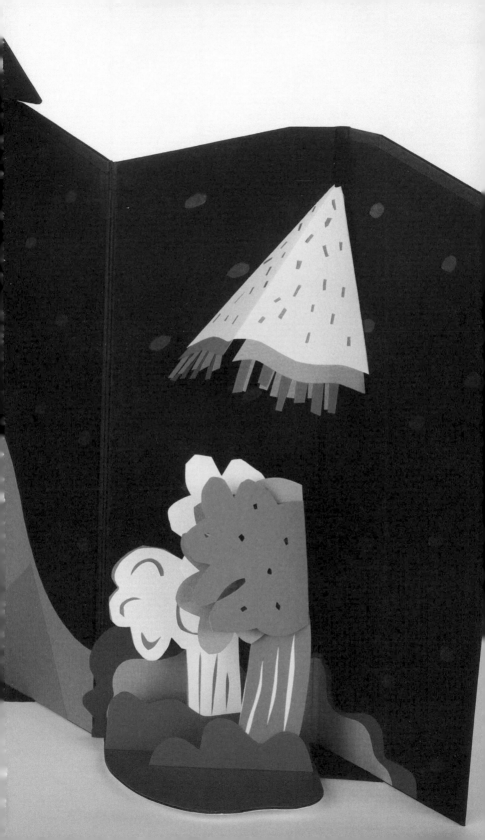

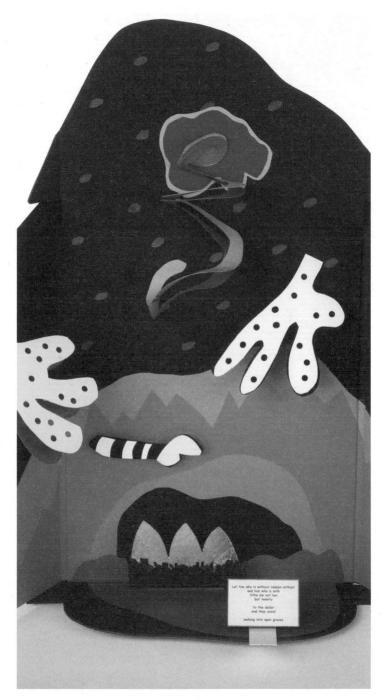

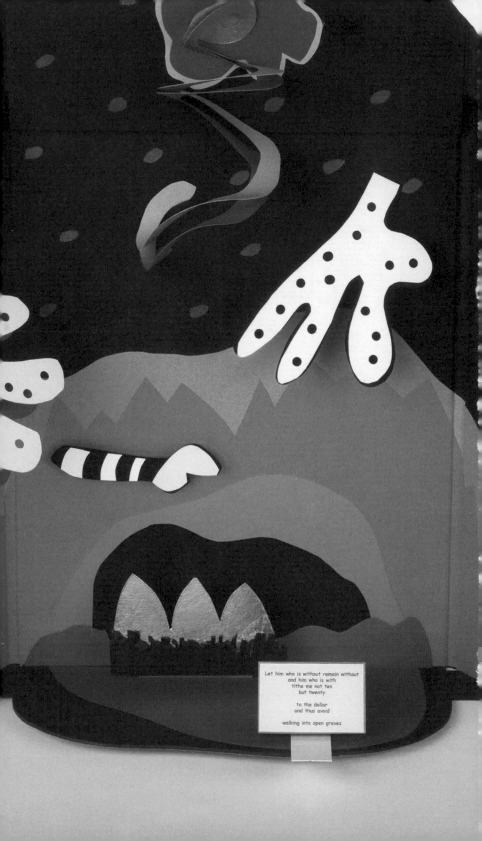

Let him who is without remain without
and him who is with
tithe me not ten
but twenty

to the dollar
and thus avoid

walking into open graves

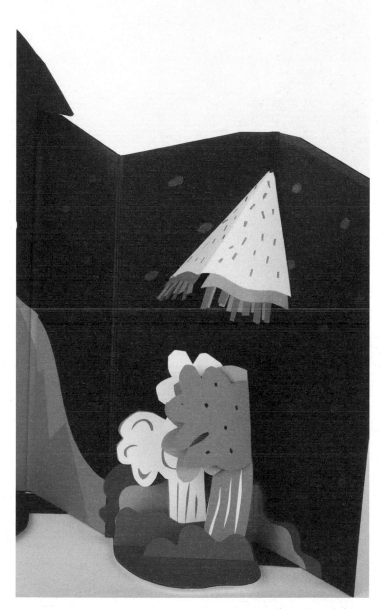

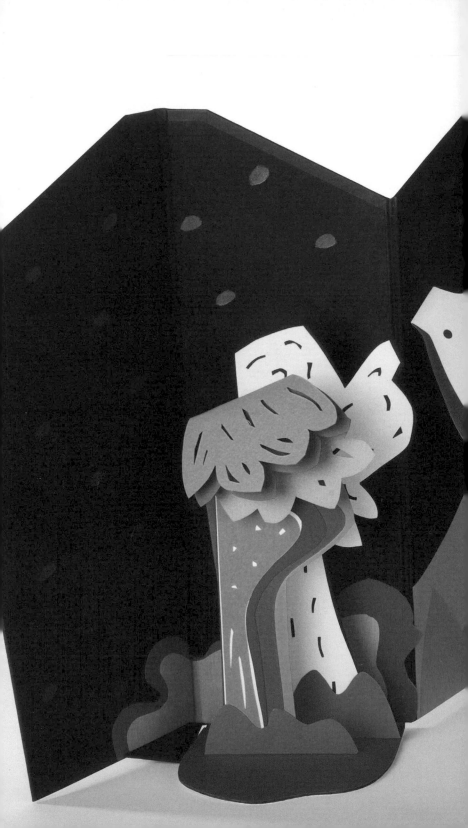

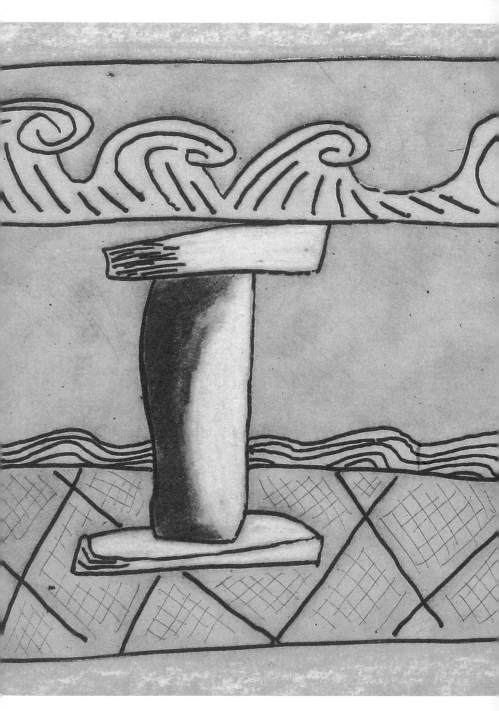

BANK PRESIDENT'S ADDRESS TO MINIONS ON THE EVE OF THE RELEASE OF THE **ANNUAL FINANCIAL REPORT** SHOWING PROFITS HERETOFORE UNSEEN IN THE WORLD

Welcome, gentlemen and ladies, and congratulations, you've gone through the stir and come out clean and cooked, the disabled unworthy have been cast aside, you've proven your mettle and are on the cusp of embattlement with mountains, climbing the ladder, to make no bones about it you are among the anointed. Tomorrow you will take up your multiple tasks in the greatest of kingdoms, the money kingdom, over which I and others of my likeness preside, preside by whit and whittle, looking after the nation's business and keeping the world's affairs afloat. You have every reason to feel proud and I'm convinced your training has taught you that our love for you, for you and your families, runs deep, it courses through you as veins course through millennia of rock, of effluvia, landslides, alterations of land mass occasioned by ice-age phenomena and other such marvels.

You are not here, though, for history lessons, there comes the time when you have taken from history all that can be profitably removed from it, you have seen this with your own eyes, I am sure, those old history buffs walking the streets in their worn-out shoes, their coats wormy at the elbows, that exhausted and defeated look in their faces, with nowhere to turn now that history has yielded its very last dribble onto their shoelaces. These are as men and women drowning in a sea of melancholy, unlike

ourselves who drive unerringly onwards into a future divested of any possibility that those of our ilk may incur a loss, save that routine loss of loved ones, love that fails us, wives that desert us, as mine did, children that give themselves over to lawlessness, druggery, and drunkenness, as mine did, loss incurred through accident, a piano falls on you from a rooftop, the faint music of wind stirring the keys as in that final second your brother or sister looked up, tsunami and such that might assail our shores, earthquakes, no matter our vigilance against such terrors, these terrors will insert themselves in our lives, sickness too, such as yesterday my very own father suffering a deadly stroke as he strapped onto his wrist a new Rolex down at Cartier's, above which he kept his delightful mistress, Agaza Strip, in a state of entitlement through forty-three stirring years.

Not that I intend to dwell on such hazards, one day it rains, another it does not, that is about all one may say about such occurrences, in my own view God was blindsided some many aeons ago, he turns a deaf ear, we might assume he has his own difficulties, his goats have escaped the pasture, that sort of thing, vines have overtaken his many mansions, grey skies day after day, a kind of exaggerated Vancouver, if one chooses to be specific, he sleeps the sleep, that's about the best we can say of him, his old head is granite upon the pillow, his wife and children occupy a madhouse wherein they may live in accordance with their needs, we need not dwell on this, we too, prince and pauper within the world of profit, have our difficulties and it is not on these that we must dwell, but rather upon the making of

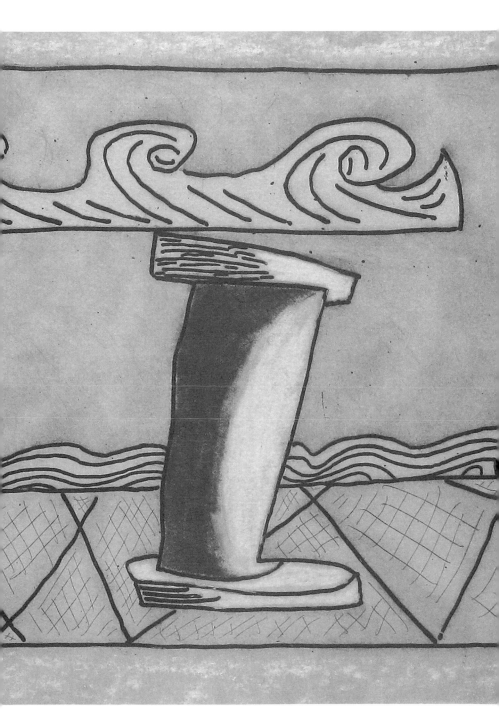

a better world as best as can be accomplished within our restricted means.

So, so, so, as tomorrow you take up your positions as number-cruncher clerks in the bastions of power, knowing that long gone are the days when we could do with our clients what we wanted to do, which was to strike them beside the head with bricks the minute they came through our door, empty their pockets, and slide them through the coal chute on a slow boat to China, never to be heard from again, alas, gone are those days of the golden harvest, now we have no option but to cook our books in the civil and accepted manner, taking as our model the fine workings of our federal, regional, and local governments, finding a bit of gold here, a bit there, picking it up the way a street person lifts a nub of cigarette from the gutter, though still one penny makes another, the pennies mount up, you will have heard that our profit last year exceeded the combined budgets of 86 nations, not bad, I'll say, when rules and regulations hem us in from every side, we are the tiger that must be caged, but the will has a way, so I say to you, gentlemen and ladies, go forth and prosper in the commercial world, make our bank proud, lift yourselves gaily from your crypt, I'll merely remind you that tomorrow, Friday, is our 'Informal Attire' day, you men may abandon your ties, you women may feel perfectly free to arrive at your station dressed in hardly anything at all, in fact we prefer this for its symbolism, you know, our historic 'leave 'em naked' motto, 'leave no stone unturned'.

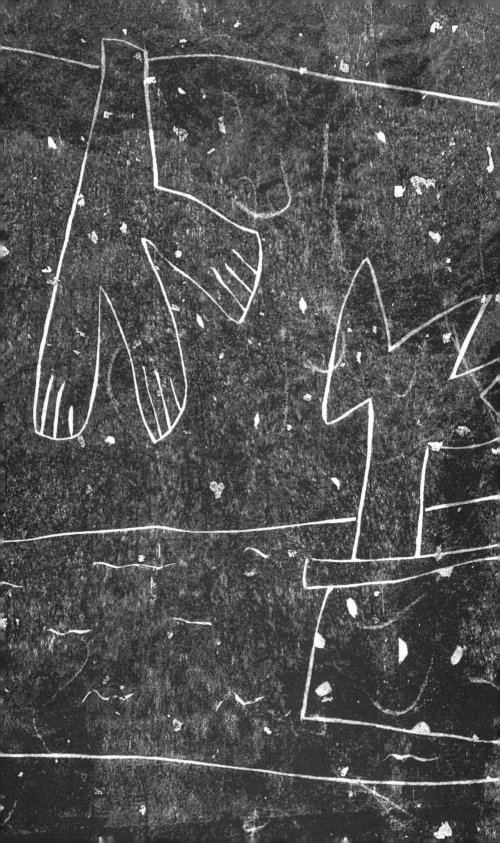

CÉZANNE'S MUSE

PART ONE

C ézanne, long-bearded even then, was startled one morning, following goat tracks over his father's old grounds, to see his muse bent over a patch of earth, her back to him, bare-legged, skirt bunched at the waist, white bloomers billowing like flags hoisted in a field. She was extracting dangerous produce from the soil, not turnip, not radish, nothing Cézanne—who was versed in these matters— had ever seen:

> curious oblong shapes that wriggled
> between her fingers like angry fish.

'Evil teeth,' she explained. 'They bite.' And showed the painter two bloodied hands, blood running down her legs like stockings on a cancan girl.

In the afternoon, Cézanne painting, the muse sat contentedly on an upturned rusted bucket, not so far removed that he didn't know she was there: her face upturned also, dropping the morning catch one by one into her mouth—still alive!—airy bubbles floating up from her mouth as she chewed:

whimpers and tiny shrieks,
the crack of bones, Cézanne's held breath,
licking blood from her fingers.

Something not quite right about that muse,
was Cézanne's lonely thought.

Cézanne's wife that night slept her backside to him, as was her custom after such summertime ploys, this her sole mode of complaint, being, on the whole, a sturdy, reliable sort—a musty, leaf-stamped woman, Pissarro said of Hortense, though not the dullard (those Salon) idiots might think.

PART TWO

Come 1868, again rejected.
('Insulting filth'.)

1869 once more the axe.

Sisley and Monet, who else, in the same basket, Mother of God, well holy fuck! 'Let's go back to Aix,' says the muse, 'spurn these ignorant bastards, never submit to that *##*ing Salon again,' the muse's simmer a boiling resentment tunnelling through cold fury.

Along the way the usual ladling of doubt—is it me, am I the cause?—resulting in a dazed frosty stare when walking, for instance, Louvre halls, a curdling in the gut unrelieved by breathless trot over untilled earth, in freezing wind, in rain, nights spent huddled with disgruntled swine.

Sunny April, 1874.

Let's stroll down the Boulevard des Capucines side by side with Cézanne, Degas, Monet, Sisley, Renoir, Pissarro, Boudin, and—look who's here, a woman, if you please—wonderful Berthe Morisot, for this renegade exhibit by the Société anonyme des artistes peintres. Note the hysteria, the hostility:

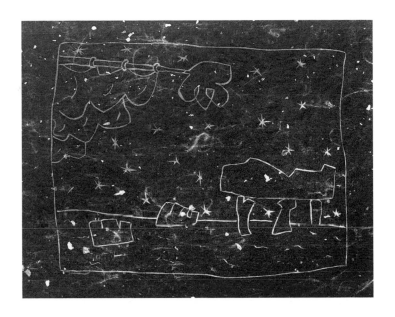

PREGNANT WOMEN, DO NOT ENTER. THIS MONSTROUS WORK WILL CAUSE DAMAGE TO YOUR UNBORN CHILD.

Hear the critic from *L'Artiste* scornfully assessing Cézanne's *Olympia*: 'A nightmare. Does the painter suffer epileptic fits? Delirium tremens? I'm told he pushes his work through the city on a barrow. A brooding nutcase, not unlike these others.'

Come 1895, critical acclaim, 'Paris captured with an apple,' no thanks to those Salon rutters.

Look, there sits the wife, with pursed lips, the decaying rose in the limp hand, *Madame Cézanne in Red Dress*, there's a self-portrait, *Cézanne in Black Hat*, there's *The Turning Road*, there, *Five Bathers*, cinders flaring from sundry burnings.

20 October 1906

> man
> discovered
> unconscious
> on road
> to Lauves
>
> dead
> two days later
> age 67

No mention made of the beautiful old muse
mourning in the boughs of the nearby apple tree ...
tearful there through the coming months and on into spring
when she became as one with the blossoming.

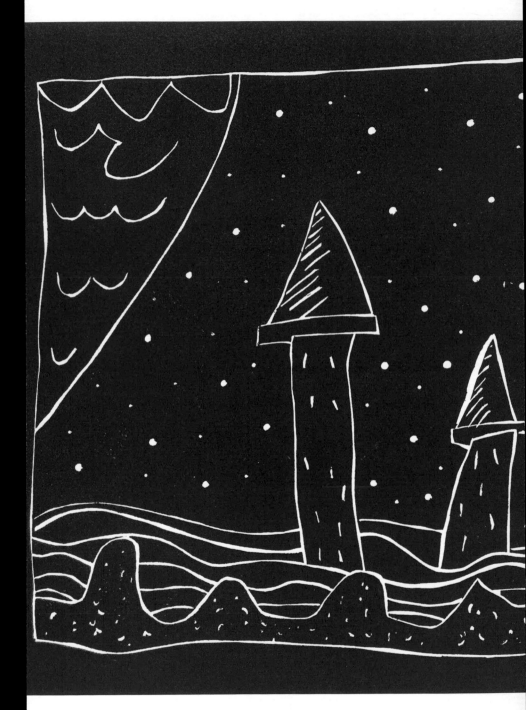

THE RAVENING BEASTS
AT FAIRY GODFATHER HOUSE

Here at godfather house we are obliged nightly at high table to slander as ravening beasts the mayors, premiers, parliaments, congresses and presidents, let's say all our masters with scant exception, a rule of law formulated by us from their example.

Such proceedings take us into dessert.

Those not ravening include: ourselves, our sweethearts, most friends, children younger than six, the woman next door who smiles at us when she has every reason not to, buxom peasant girls of whatever country, black musicians who sold their souls to the devil at Mississippi crossroads, kind-hearted librarians, women who have kissed frogs whether or not this kiss changed their lives, soufflé chefs, women who nightly ferry the Potomac in redress of new crimes of the administration, women who dab vanilla flavouring behind their ears, Labrador women who periodically fall through ice from the weight of noble intentions, backroom refugees on the Danforth who repair without charge the torn hems of angels, invisible women who leave the halo of their suffering in sodium bulbs illuminating our thoroughfares, Italians who have taken the name X, the unknown parties who ever show a pinpoint of light at the end of our tunnels, the Lisbon faction of the Society for the Innovation of Short Fiction,

the child in Buenos Aires who correctly articulated the plight of blind owls in and around Coronel Dorrego when by mistake he ran into a door in the dark of winter while fetching a glass of water for a blind sister, those who polish our steeples in the dead of winter, and my lover who warmly says goodnight to me every morning.

Toasts to the above take us through dessert and final evening prayers, after which we are called to order, reminded of our mandate (it is spelled out in our constitution), and give vent as one body to godfather house's rousing cheer ...

Thus, the day's business concluded, higher officials retired to their tower beds, we go out and raven as ravenous beasts until the knock of dawn, spurred on by the hissing of oleander bushes, trellised roses, monkshood, the panting of mongrels begging for second breath, bleached skulls hanging from boughs bent by all that came before our society was formed.

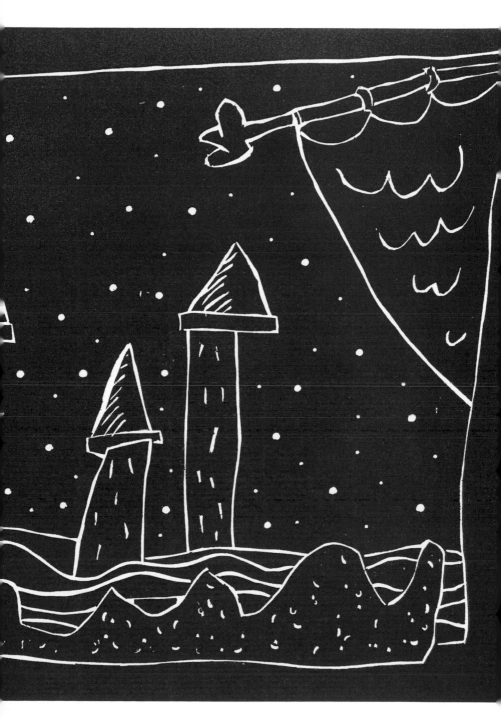

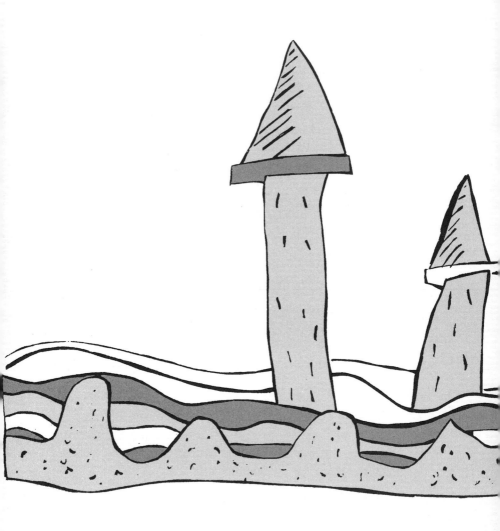

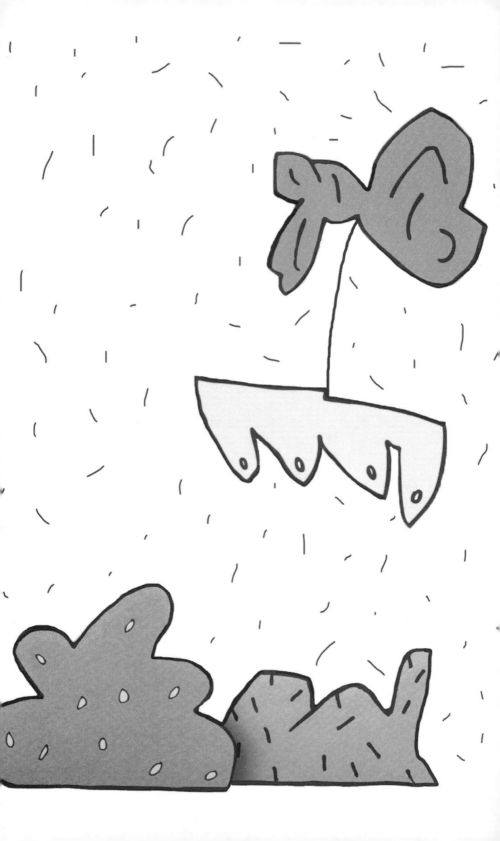

MS SMITH IS HARD PUT TO EXPLAIN
TO HER HUSBAND
HOW SHE CAME TO SPEND THE NIGHT
UNEXPECTEDLY
IN PHILIP'S NIGHTGOWN

To begin with, dear one, you might show some sympathy in understanding that both Philip and I had been gallopeding on grey ponies over the downs during which hours there transpired a tonnage of vapid and melancholy revelations touching upon certain indiscretions and outrages pertinent to your youth at this country house you and your brother Philip shared with other familial parties and some guests who I hope for decency's sake shall remain nameless, if ours is to be a civilized discussion. Before our gallopeding, which is a word I shall employ to my heart's content, despite your rude grimaces, since it was a word of which Ms Virginia Woolf was extremely fond, and since I am extremely fond of Ms Woolf, or Ms Someone Else as she was once upon a time. Before our gallopeding, as I was saying, Philip had sent me a large pot of face cream, as a show of neighbourly affection, I suppose, and after our gallopeding we were, in a word, 'among our olives', frugally bypassing any idea as to the consumption of dinner. We were served our gin olives by Philip's Scots person, that twinkly-faced bitch I believe I have been told hails from the island of Islay, and emits, as you may have yourself mentioned, the scent of peat from under her nails and between her toes. Philip directed this person, when she wasn't busy fetching our olives, to run and turn down my bed and lay out my jammies in the East Room, and of course that dotty tramp got on her high horse

and laid out Philip's nightgown in the East Room and my jam-
mies on Philip's bed in the West Room, and when the crank of
the evening fell who among us knew which way was east and
which west and what tangle of whose cloth one was heaving over
one's shoulders.

(Here Ms Smith takes a deep breath before continuing.)

Thence ensued a bleak and black moment during which time
went gallopeding to its own beck and call, or hew and hack, and
next I knew your dear Philip was shouting down the pipes, the
actual in-house ORGAN pipes in the attic, if you please, in the
attic of that ridiculous PILE, as if we were suddenly domiciled in
bloody Christ Church Cathedral. Had I found his love token in
the jar of cream, Philip wanted to know, and was he ever
doomed to be his brother's keeper, and other such rot, not a
word of which I could tolerate because now he was shouting that
to his mind I possessed too little regard for nature to fit securely
into his family, which rude remark I took sore exception to, and
at some point shortly thereafter, both of us back in the DRAWING
ROOM, I pointed out to the oaf a thing or two about the raddled
and putrid nature of this precious family over the past aeons,
and how the two of you dear despot brothers spend your time
these days toiling over the women of this and that cantankerous
nation, one as Director of International Relations and the other
as nincompoop foot soldier to the cause, both obsessing over
these idiotic adulterous Scotswomen who

cannay gae a day	their mince and tatties,
without eating their tatties,	their foul tattie soup
without	and tattie scones and
cooking up	tattie skink

which is what the bitch had rattled up for our prospective dinner and why I chose, if you must know, to hang in with the
olives. About this hour it was Philip drinking from the shaker,
him all skiddle-skaddle and looking a fright in my jammies,
and that four-tittied bitch of a Scots girl down to the buff galloping on a grey pony around and around the castle walls
and jumping stumps and your dear brother at a window shouting proposals of marriage. I am pretty sure I went cold sober at
this maudlin sight, and actually went into the kitchen and ate
any number of

> cold tatties
> and drank cold tattie soup
> and swallowed tattie scones
> till I popped,

thence sending myself off to bed like a lady, only it was on the
billiards table under the dog blanket where I slept and where
you found me, and why you are making that ugly face at me
this minute only God or the devil in a swimsuit can understand
and if you do not cease and desist this very second

I will flee our joyful marriage and fleece you for EVERY

> p-p-p-penny.

(Here Ms Smith weeps, and weeps, though
not so much it will tire her eyes.)

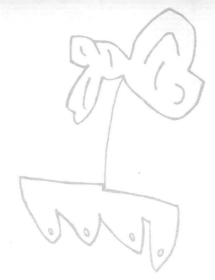

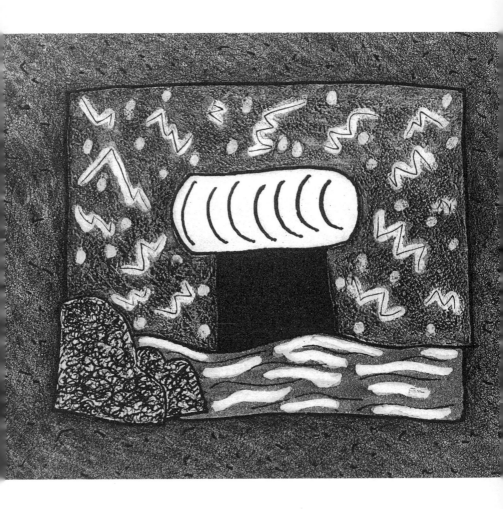

THE SCROLL OF CIVILIZATION SURVIVES THE RESTLESS DEEP, SIGHTS THROUGH RUSTED PERISCOPE THE UNINHABITED ISLE IT MAY CALL HOME, AND NAVIGATES INTO SHORE ON A CALM SEA

When the painter Exubrio went down to the sea seeking to execute himself, having previously hung an endless array of publicly renounced paintings upon wires strung between posts artfully arranged an exact twelve feet apart and an exact twelve from the shore's high tide, his own arrival timed to precede by just minutes the onslaught of a storm that would shake the very earth with its lightning and thunderbolts ... when he did so, Exubrio believed he knew precisely what he was doing.

He had spoken to olive growers and vineyard masters in the vicinity to determine at what precise moment the fearsome storm would arrive, and had disputed at tedious length with his wife over which precious canvases he must, please, under no circumstances, please, my darling Exubrio, hang for the tide to engulf and remove to Davy Jones's locker.

Exubrio's idea being that with himself as electrified corpse and no longer prone to second thoughts as to his talent, and a fine sleeping potion secretly inserted into his unhappily embattled wife's evening tea, these paintings which critics and the public so reviled would be ignited by lightning or swept away by angry waves to find at last their unlamented grave in the deep.

'Eight o'clock, love,' he said that night to the snoozing wife, as the clock struck eight and the sky unleashed a black rain. 'Time I went.' The wife, an Italian woman named Denuncia Francesca Illuminati Luminesa, of aristocratic descent and herself a sculptor often reviled, had said many times over to Exubrio about these paintings he would offer up to fate.

'No, not that one, nor that one, never this one, and certainly not this benign sea-monster creature said to carry the scroll revealing the treasures of the past, the destiny of civilization! No! Nor throw out Cézanne's Muses 1 and 2, nor Appalling Scenes nor Lousy Pessimists nor Those Scotswomen, nor for that matter these here nor those there, nor that bunch you have so deftly entitled *Untitled*.'

Furthermore, in a move designed to steer her suicidal, manic-depressive, hyperventilating husband from his intention, and in the mistaken belief that certain paintings in this household were sacred, untouchable, she has said to him:

'Only, and only if you must, my darling, surrender to the elements these numerous portraits of, for instance, me. I beg you, for destruction take this portrait of me here in my red dress with the dead rose in my lap, the bee on my knee, or this one watercolour of me done I believe on our wedding night. Or this portrait of our dear daughter Cherise hanging by her thumbs from that window in Provence, and you absent, ever absent, only your shadow protruding downwards from the frame over my bare flesh, in one of your moods, I suppose, heaven help us, as Cézanne's Hortense was always saying.'

And so she went on in her deceptive culling of which paintings to

surrender to fate, and which to save, for she would save all if she could:

'So many family portraits you have done, me here with the cat, Blur, in my ostrich pose, Cherise there playing hide-and-seek behind a green bush, me here again as a lover in the bath, "after Courbet's *Origin*," I believe you said. So many and so many paintings depicting the intimate family hour, *Portrait of Denuncia with Fruit Basket, Denuncia Seated with Bird, Cherise Under Flowering Apple Tree*—if the current carries these paintings out to sea such a loss to my heart and to society it will be, yet if you must then you may, I too am forlorn at your having to wallpaper and paint, to venture forth with hammer and nail each day, and myself having to clean toilet bowls, and our child to eat worm soup, ah, we despair, do we not, and whenever did we not, and why can we not continue on in the desperate pathway we have followed lo these many years?'

Good question, any of us might say, but Exubrio was fed up with this indifference to his and the wife's work, and even lovely Cherise at school has been punching dearest friends in the chops. So Exubrio remained intent upon taking ALL of his life's work under lightning bolts to be scorched or dispatched into the deep, while he allowed Denuncia to believe that her ruse had succeeded, that he would save at least the paintings sacred to their love.

Imagine this, then: how astounded Denuncia was when on the morning of the last day Exubrio, without a tear, his footsteps only a trifle leaden, began rounding up for destruction these very paintings.

'They are all one and the same,' he said, 'insofar as they are anything, all fossilizing even as the paint dries. So let's be done with it.'

Exubrio ignored her cries of rage, her anguished efforts all that day to stop him. And beautiful Denuncia, she of noble blood tracing back to pre-Medici days, would at the last have plunged a knife into this villain's breast had not the sleeping potion dropped into her tea compelled her pulse at that moment to slow, her head to nod, her breath to leap as a gazelle summoned to lazy dream.

Thus Exubrio did as planned, and here, epochs later, appears on the horizon *The Scroll of Civilization*, up untainted from the deep, and slowly, with caution, navigating for the unpopulated isle.

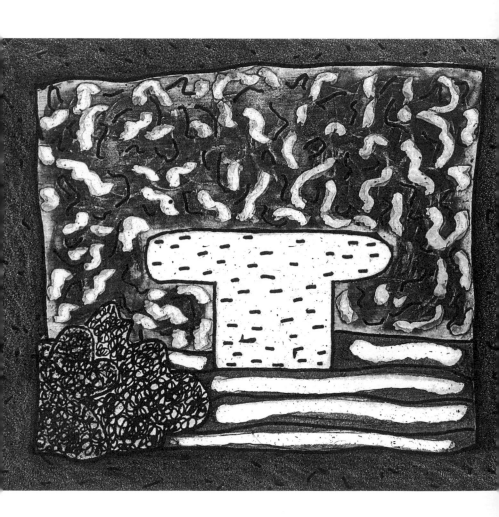

SON OF SCROLL

A few questions put to Son of Scroll.

Q: Have you seen any Indians afoot on this isle?

A: Afoot, no.

Q: Any witches?

A: Some.

Q: What happened?

A: They said they wouldn't eat me if I sang to them.

Q: Did you?

A: No. They sang to me.

Q: Are you lonely on this isle all by yourself?

A: I'm not all by myself. I tried to be. It didn't work.

Q: Who's this Susie we've been told about?

A: The little red-headed crippled girl who polishes Pop's
 periscope.

Q: That's a nice T-shirt. Who makes your clothes?

A: Children in Hong Kong.

Pause. A thin rain begins to fall.
It falls harder.
The sky turns black.

SON OF SCROLL: Excuse me. One would have to be an idiot
 to stay outside in this muck.

He goes. The interrogator's mouth, ears, and nose fill with rain-
water. The interrogator drowns. Drumming and chanting is
heard from Natives in the bush. Witches sing.

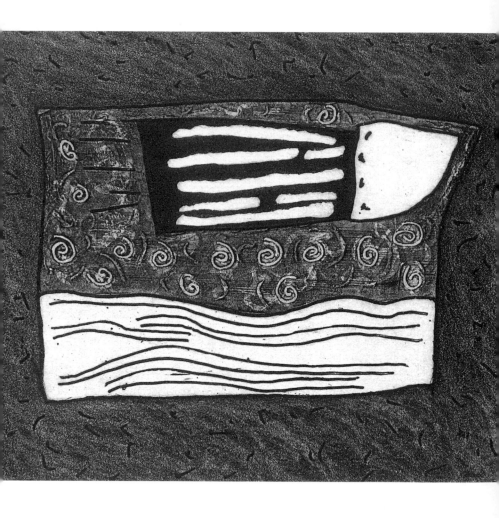

DAUGHTER OF SON OF SCROLL

April sat alone with God in a dark corner, talking initially about the correct hemline for one of her age and station, a subject about which God had firm opinions.

As the evening wore on God's behaviour became wanton, he snatched up her skirt, muttering uncomplimentary remarks not to be repeated here. Falling from his pockets were Post-it reminders of ten million to be slaughtered in a distant province, concocted as he slept, and Leonardo-inspired sketches of airborne torpedos, a prank he meant to play on unsuspecting hordes in the near future. He smiled cheerfully when April refused his kisses, spoke clumsily of the renowned afterlife he alone was capable of insuring.

In a show of affection he took the very tongue from her mouth and reproduced it on her shoes as leather, the tongue down there mouthing complaint about how she was a woman, had come through to so many sad endings from so many unrecognized beginnings, so many streets existing as portals into hell, the times she'd had to tell lovers to go f*u*c*k themselves, yet had often, had often, often, *with dazzling frequency* witnessed hair-raising beauty.

God, silent during this speech, was later seen dancing with women owning higher bosoms. For a while he took the mike and crooned a few love ballads for old-time's sake, mimicking Sinatra, finally leaving the dance hall in the company of bearded disciples all shouting, 'My Lord, whither goest we next, it not yet even the shank end of evening?'

PECULIAR PRACTICES

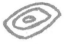

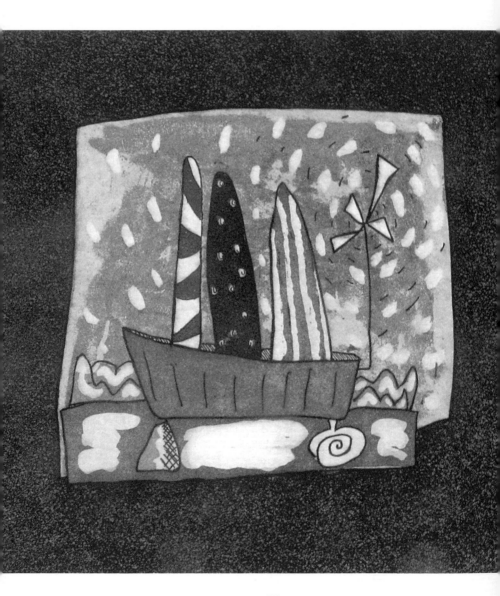

SNOOP, PROTÉGÉ OF SNAP

SNOOP: Snoop! Protégé of Snap!

SNAP: Yes! My landlubber boat in radiant sail!

SNOOP: Like those who see Mary weeping, in some rag
picked up from a ditch!

SNAP: In radiant sail!

SNOOP: Do Snoop. Hang Snoop in a museum!

SNAP: The very grasses of the earth!
The hindmost moon in orbit!

SNOOP: Mary weeps!

SNAP: Love uncorked from a bottle! Setting sail!

SNOOP: Snoop!

SNAP: Protégé of Snap!

SNOOP: Give us yowling!

(We hear yowling.)

SNAP: Give us spunk! Song!

(We hear song.)

ALL: Art is the heart, the heart's cradle! We are the sun!

(To crescendo.)

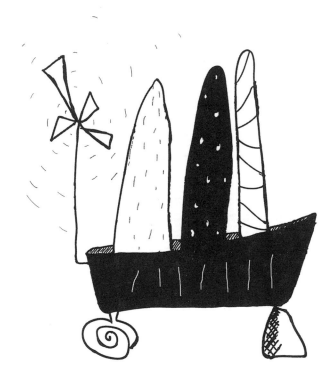

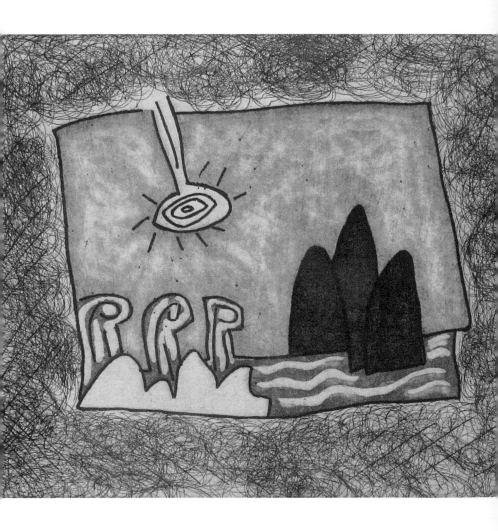

I SPENT THIS DAY TOILING
OVER A NUMBER OF SCOTSWOMEN

They were large Scotswomen, of considerable vigour, each of whom had first to pass the scrutiny of my secretary, Ms Smith.

Ms Smith is not herself a Scot and did not take warmly to them.

I told Ms Smith that if any more Scotswomen came through our door she was not to offer them strong drink or allow them to smoke in the hallway, and that furthermore I would prefer the next day's haul, from whatever country, be dressed less provocatively, no more stiletto heels, and see to it that their wee weans remained at home.

Even so, I toiled relentlessly over this number of Scotswomen and made great headway in determining the native temperament and gauging the Scotswomen's time-tested endowments.

Ms Smith and I stole away for a two-hour lunch at McNabs, with appropriate liquids.

Back at the Institution, as planned, Ms Smith appeared each fifteen minutes with news that I was wanted on the telephone, a manoeuvre which considerably rankled these Scotswomen, and led to intemperate outbursts, to wit:

'Aye, n what's she havering oon aboot!'

'Shut yer geggie!'

'Ye mither is ma yeukie coo!'

Some findings: Glaswegian women are hardest to satisfy.

'Nay, donae gae yet ye rummle willie!'

The Speyside wench crosses her eyes during the act and has an abundance of frizzie hair betwixt and between.

'Here's pook in ye eye, ye daft neep!'

The Islay wench has particular needs.

'Yikes, n would ye pit the stritch tae mae toes n tie the bonnet tae mae chin!'

Ms Smith will have my full report on the Lord Provost's desk come the A.M. Tomorrow the Orkney and Shetland busloads arrive, after that the Dumfriesshire and Border trains.

'Are ye a wee bit puggled?' asks Ms Smith, and in reply I give her a guid churn. Now we are off to have a bite and see the shows.

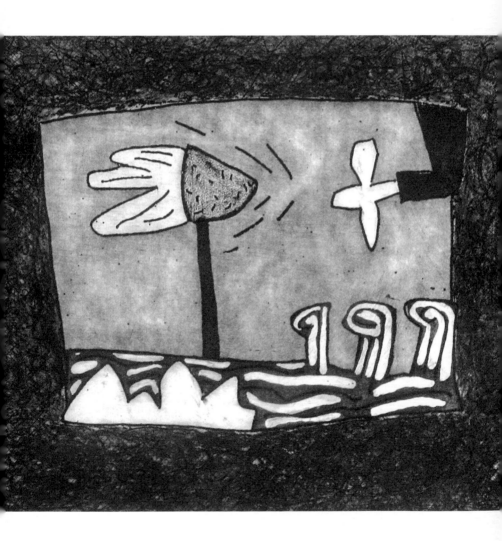

THOSE LOUSY PESSIMISTS
SOMETIMES MAKE A GUY SO BLUE
ALL HE WANTS TO DO IS RUN AMUCK

I found myself in a land of misery through no fault of my own, no fault of my own, and I was walking off the blues, walking them off, casting these blues away the way a man would cast a fishing line, when this warm hand slid into mine, then this hand had become a full arm and that arm was encircling my waist, then that other hand was joining the action that other one was in the form of smooth fingers up over my face I was finding it difficult to walk with these, you might say, encumbrances, so I opened the one eye quite narrowly so as to spot the bench that I knew had to be around someplace and there the bench was so I sat down and the one hand quit my face and now both of those hands were up doing a rapture business over my face and then I felt this warm business over my lap so I slung open the eye about the width it would take a dime to slide through and in this slit I saw it was a ravishing woman taking up residence over my lap, I mean the part of this ravishing woman's anatomy you might expect would be doing that sort of thing, and about then I detected this creature had a voice, a lovely voice, and this voice was saying:

'Shhh, lover, don't say a word', and quite naturally I didn't, wasn't I speechless anyhow, and these beautiful lips were parted, I suppose, in the speaking of this 'Shhh don't say a word', and they were quite close to my own lips, that much

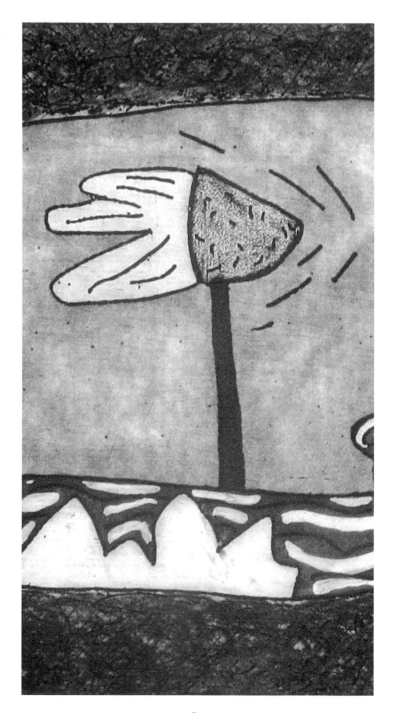

I could now see through the parted slits of both eyes, I
who an hour ago had been told I was blind, yes, blind,
yes blind and stupid and past the pale, just to mention a few
things I had been told in the past hour and in fact over the
past few days, though I was not dwelling on these harsh remarks
at the moment because at the moment this ravishing woman's
lips were crushing mine and both those hands were up in my
hair or behind my neck or elsewhere, the crying shame is I could
hardly tell where those hands were so much were they every-
where, and that beautiful mouth too, I think without being
obscene in the telling I can say that mouth was up and down and
all over and along about this time I got my wits together, after all
I was for all intent purposes a sane and adult human being and
as one of those I felt compelled to say, 'Darling, who ARE you,
darling, who are you', and just like that the hands and face took
leave of my person and I heard this frightful voice saying

DIDN'T I TELL YOU TO SHUT YOUR MOUTH CAN'T YOU DO ANY-
THING A WOMAN TELLS YOU OR ARE YOU JUST A FAT STUPID
MORON MOTHERFUCKER WITHOUT A BRAIN IN YOUR HEAD

and by the end of this violent overlong outburst why naturally I had
both eyes wide open and there were about a dozen people ringing
my bench, mothers giving brisk shakes to baby carriages, little
girls blowing bubble gum, teenagers with studded lips, and
backpackers and couples weighed down with packages, and
ruffians of every stripe, and all of them gawking, passing such
remarks as

DISGRACEFUL AND IN PUBLIC TOO AND BE ASHAMED OF
YOURSELF!

so I knew I had better escape that place fast and I did, I jumped up, I said 'Excuse me please', and I ran all the way home I ran fast as an antelope might scurry, and as I got home and rushed through the door there was this gasp to be heard, and Ms Smith was running towards me, she was throwing her arms around my neck and all but smothering me, saying

DARLING I WAS SO WORRIED I WAS IN FEAR OF YOUR LIFE.

And you might think by now I was a total ninny, but I wasn't, I was giving her back exactly what she gave me and I knew in the fullness of my heart that she and I had cast off our blues and would live happily ever after, or as a lousy pessimist might say, which people this earth is entirely too full of, at least until tomorrow.

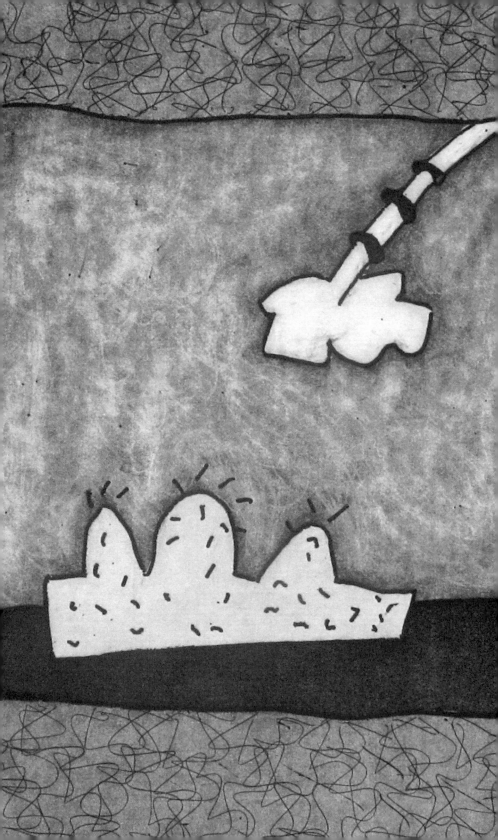

PECULIAR PRACTICES IN ALBERTA
POSSIBLY RELATED TO THE OIL BOOM

I went to the supermarket and a woman wearing see-through shoes shot her hand into mine and began dragging me into Meats. Susy was the name that was pinned on her white blouse.

I would have gone with her into Meats had not another woman, Rosy, taken my other hand and pulled me into Poultry. What's that? I asked Rosy, and was told that was a machine for de-frocking birds. Until then I had never known they did on-site plucking.

'That's a giant turkey,' she said when she saw where I was next looking. 'It won the Founders Award. Are you ready?'

(I wasn't nearly ready but with practised aforeplay she corrected this oversight briskly. When we were done she said, 'They are expecting you in Bakery.'

'Bakery?'

'Lots of action in Bakery,' she said. 'Dairy, Frozen Foods, okay too. If I were you I'd avoid Fresh Vegetables.'

'Does this go on here all the time?' I asked.

'Most days,' she said, 'when we're not in a panic. Do you remember those days when our nation was busy snatching furry creatures? In here, it's often like that. We yank people off the street if we're in the mood for sexual activity. It's like those eighteen months down south when we had the Pony Express. Rush, rush, rush!'

My fine white suit dissolved into ash in that long moment during which I could formulate no reply.

Bakery was calling. 'Are you ready?' this beautiful woman shouted. 'We don't have a lot of time. It's not like you got to know your Heidegger.'

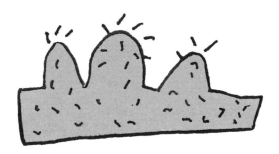

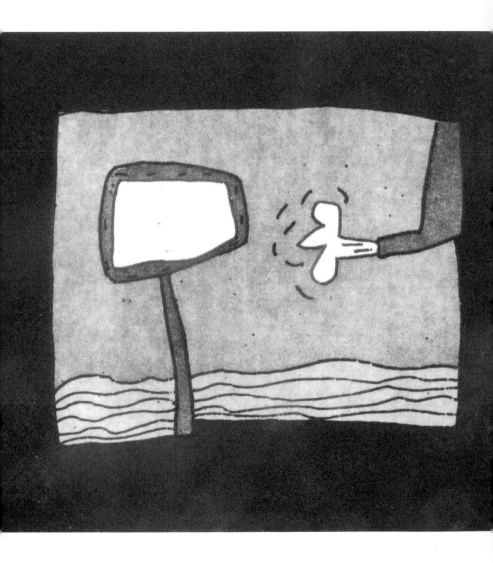

NARCISSISTIC EB AND UNLUCKY FLO

We were down among the strippy currents basking in the afterglow of having torn ourselves apart when my true love said, 'You should let some of your feminine side out.' I said, 'If I let it out it will most certainly be slapped into prison.'

She said, 'Give it a whirl.'

I let my feminine side out just for a minute and instantly it started dancing on its toes. It was going at this big-time.

'Put it back,' she said. 'You let too much of it out.'

'Well, gosh!' I said. 'Well, golly!'

I tried putting the whole thing back, but it ran one way and another and soon disappeared. It had gone to Florida. It had gone to the Sunshine Coast. Gone to where it could wear a bikini without being cold or arrested for conduct unbecoming to—

'I'm not hanging in with you any longer,' she said.

'You've gone all nasty masculine.'

'My feminine side has gone to a place where it can fulfill its destiny.'

'Get off me,' she said. 'Get off me now.'

'I found it hard to love my mother,' I said. 'She was a hard woman.'

'Sometimes I hate people,' she said. 'I hate people who refuse to comb their hair. I'm very fond of feet, though. I have very nice feet. My mother used to tell me that. "You have very nice feet, Ruth," she'd say to me. Ruth was my sister. Mother was always confusing one of us with the other. She led a very confused life, my mother. I believe she never enjoyed a sturdy moment. She saw life through a prism of her own devising. The dog was the one party in our house able to tell Ruth and me apart. She was a most excitable dog. The house shook from that dog's excitement and then you'd discover it was excited over nothing. Except that time the house burnt down. That time was different.'

'Are you done?' I said. 'Are you quite finished?'

'Would you please get off me,' she said.
'I can't breathe down here. I'm dying. You ought to go to the gym and lose that flab.'

'What was all that stuff about dying with your boots on, I wonder?'

'What stuff?'

'I never got it. That "boots on" business. What was the point? There was a lot of stuff like that in my childhood that I never got.'

'Me, too. Like how you got me.'

'That boot business bothers me. I'm a deeply troubled guy. Yet this is pretty good, us here like this. If there were a heaven, it would be exactly like this. Look, there's my feminine side coming back. Wow, get a load of that outfit. Been shopping, I guess. A flaming dyke!'

'Arsehole.'

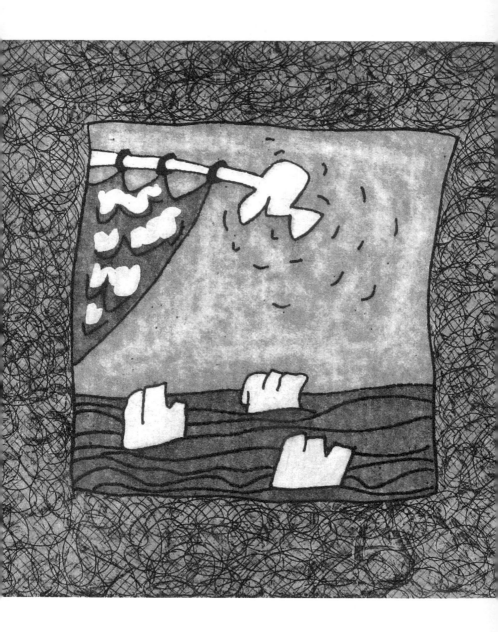

SOME IDEAS
ABOUT THE CAMPING EXPERIENCE
NEED LOOKING AT AGAIN

Our guide abandoned us on Lake Nipissing and we wandered for an unknown time in wilderness. It was during this while that I married Evangeline. Thank God I did so when no one was looking or I would have been in deep trouble with those other women who wanted me, or men who wanted Evangeline. We all wanted something.

Warm clothing, food, water, dry matches—what they call the essentials. We had long fights over these essentials, then we didn't have them and thus had nothing to fight over, unless we decided to fight merely to make things interesting. Which we did, and always at sundown. I can't recall how many people I had to fight to retain Evangeline or how often I had to fight her, which I did initially only to get attention. Some of us died because of the attention we were not getting.

It was into the third month before Evangeline first spoke to me. This was during a humid spell when none of us were talking to each other. A suspicion existed that our guide had not truly abandoned us, that someone in our group had poisoned our guide because she refused to marry him. She was a fine beauty, I will say that, and we all wanted to stay in her good graces so she wouldn't hit us and would share her jelly and let us ride the mules across those trails in and around Lake Nipissing.

Frankly, I didn't care for Lake Nipissing. At night wild animals shrieked. Then the snows. My thumbs icy, I wondered why my parents had signed me up for such hardship.

Evangeline swore she loved me. She swore marrying me ranked up there among the smartest ideas she ever had. I asked her what was another smart thing you did. For a second or two I thought she was going to come up with something. She didn't, so we went on with our kissing. We went on with it all night and in the morning the campfire was out, everyone was gone, and we were more lost than ever—in and around dreaded Lake Nipissing. If such is where we were. You're lost, it is not as though you can put your finger on a map.

These days, when our child (Bonnie) asks about our early days, was it artificial insemination or what that produced her, Evangeline and I don't say much.

We don't say much generally, and—generally—Bonnie knows when to hold her tongue. We keep her close by. No camping for that girl.

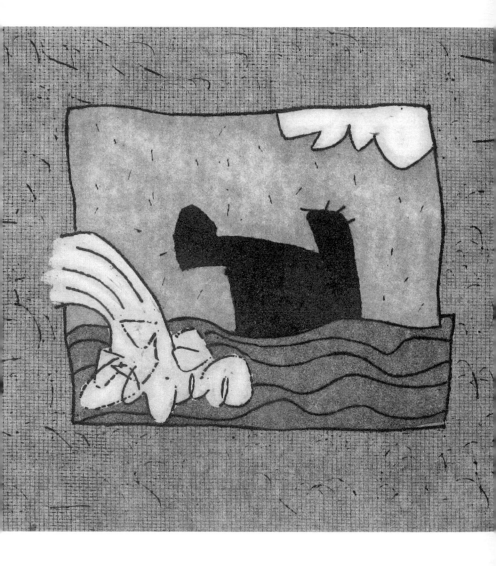

The entire time! The tension! I was pure poured concrete for four hours and forty-six minutes.'

'Right on. It was so right on.'

'I didn't dare blink. My attention didn't wane even when you touched me.'

'That wasn't me.'

'Not even to eat my popcorn. You mean it was the guy on my right? In the raincoat? His hand between my legs?'

'What a tribute to that movie. That guy could have climbed all over you and would you have known?'

'Kool. Oh way kool. Who was that guy?'

'In the raincoat? The director, I think.'

'Of *Documentary of…*?'

'Yee-oh! The big chief himself.'

'Oh God. Say it again. Tank stroked my thighs? Mr Slow Motion. The king? I swear to you this man has made a film the very equivalent of Proust.'

'Ah, Proust! Another masterpiece of the first walk was Proust.'

'Eighty-two hours and forty-six minutes of sheer unutterable utterance. Who can ever forget Proust propped up in his cork-lined bed, that semi-dark room, never the smallest noise save that of ink smacking the page, the single sustained camera position through eighty-two hours as the dear asthmatic neurasthenic composes the sixteen volumes of *À la recherche du temps perdu*.'

'Time! When has time ever been better comprehended?'

'Yes! And the cup of tea, the bit of cake. The crumbs on his chest. Sheer genius. My heart stopped. It just went pitter-patter and stopped.'

'Wasn't Proust a Tank?'

'Definitely. When he was married to that little red-headed girl in the green shoes.'

'Whose eye is it in *Documentary*? Do you think it was the Eye of God?'

'It was Mel Gibson's eye, stupid.'

'Yeah, but like, whose eye was Mel's eye playing?'

'There you got me.'

'Let's go back tonight. *The Documentary of the Closing Eye* is utter riveting drama played out on a heretofore unrecognized human scale. When that eye finally clanged shut after four hours and forty-six minutes, it was as though eternity had closed its doors.'

'*Closing Eye Two* comes out next year. I hear in that one he's got something in his eye.'

'Mel? God? You mean like …?'

'Yeah. Grain of sand. Grit. Maybe a twitch.'

'Jesus. That's so—so …'

'Biblical?'

'Yeah. Such a daring treatise on—on …'

'The failure of philosophy. The phenomenological meltdown. Our moral quagmire.'

'God, yes. Oh, the agony. I can't wait.'

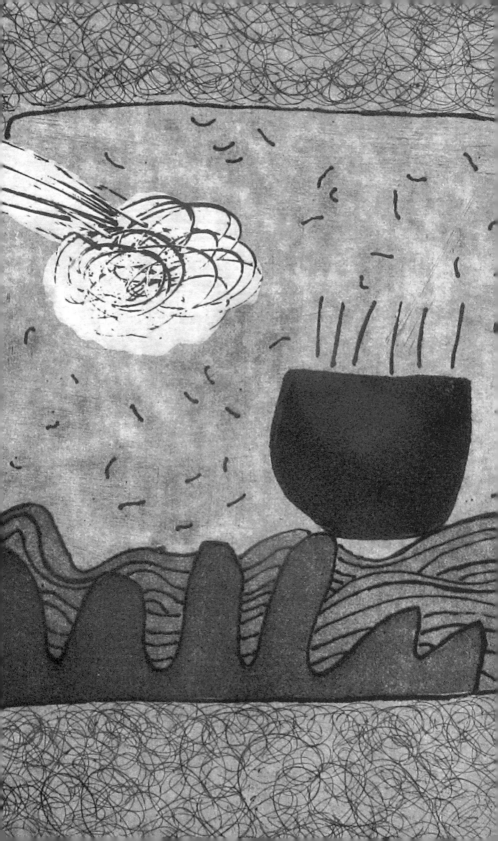

SULLENNESS IN MACHINES
IN ADVANCE OF OUTRIGHT RAGE

The washing machine tosses off obscene remarks

like bigots in a snowstorm.

It whirls into deep remorse and spends the night crying.

It wants its lid raised and to hear speeches idealizing rust.

It fills with water like a trickling brook

and sits waiting for you to drop in bricks.

It has twisty daydreams and knows by name

the mice snickering on the cold floor.

Saphead.

Pimp.

Whoring bitch.

Those are its favourite words.

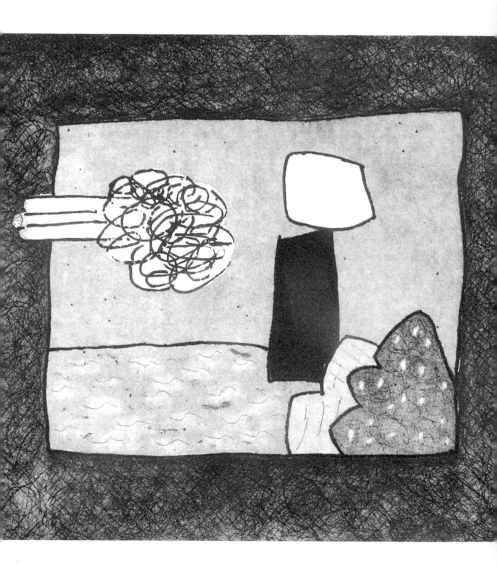

LET US STEEL OURSELVES
FOR THE APPALLING SCENE
CERTAIN TO DEVELOP
SHOULD WE EVER DECLARE OUR LOVE
FOR McTAGGERT'S WIFE

———————————

I t's as I said to yon McTaggert's wife only the other night.

What did yer say? Was her head on yer pillow?

It's like this, lassie, I said. Yer man strolls the high valley of discontent. Yer man tarries in the deep shade of incomprehension.

That aboot nails the rat, I'd surmise.

Yer man strolls the pale bluffs of circumstance, I said. Yer man meanders the long valley of … valley of … I forgit what it were I were saying.

And how did the fine lassie take yer calculation? Did she tear out yer hair?

Valley of melancholy. That's what I were saying. Yer man McTaggert meanders the long valley of melancholy with no regard for the beauty of yer face and the soundness of yer character. Or yer bonnie long limbs. That's what I were saying.

Well. Well, I seen her giving ye the eye. I seen ye doing some meandering, strolling, some tarrying yerself.

Do yer know? Confound me, the lassie will nae remove her knickers in daylight. ' 'Tis a moral principal,' says she. She'll nae blossom except in full dark.

Agh, that's evil. That's doomsday coming.

Yerself is the encyclopedia of illusion, I said to her. I said it to her straight out. Honey, I said, yer is the 'pilgrim transalpine'.

COMMA FUCKED

A five-dollar bill driving a red Datsun picked me up at home fuck two tens in a hatchback replaced the five at Henry Boulevard fuck as I passed the First National four twenties in a Caddy caught my tail.

I left Holt Renfrew empty-handed fuck slipping a dollar to the doorman who told me a lift-off from the roof was set to go in two minutes. I made it fuck we lifted off fuck losing the tail.

I reached Sally's Cut Above where the same Caddy was waiting. I came out with a Sally gown (evening wear) fuck new earrings fuck a black wig on my head. I shook off the posse and had three free hours fuck until about six fuck it was fuck when the five-dollar bill in the Datsun picked me up at the Spadina subway exit fuck following me home.

I fed the dog fuck had a long bath fuck made up my face and put back on the Sally gown. At nine I took a taxi to the hotel fuck trailed by a thousand-dollar bill in a black limo fuck a new kid on the block.

Shooting broke out at Bloor and St. George. I wasn't involved.

A guy on an eighth-floor scaffold at the Continental fuck cleaning windows fuck dropped down fuck shouting fuck get down fuck get down. I did fuck I got down.

At my own hotel fuck my lover had already ordered my drink fuck martini in a blue glass fuck with a lemon twist.

'Lovely fuck' I said.

TONY CALZETTA

Over the last thirty-six years, since receiving his BFA from the University of Windsor and his MFA from York University, Tony Calzetta has exhibited continually in solo and group exhibitions. He works mainly on canvas and paper and at times in sculpture and printmaking. In addition to commissioned works he is represented in public, corporate and private collections in Canada, the U.S. and Europe. In 2011, his paintings were exhibited as part of the Padiglione Italia at the 54th International Venice Biennale. Calzetta was elected as a member of the Royal Canadian Academy of Arts (RCA) in 2004.

LEON ROOKE

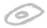

An energetic and prolific storyteller, Leon Rooke writes in a style characterized by inventive language, experimental form and a wide range of characters with distinctive voices. He has written a number of plays for radio and stage and more than three hundred published short stories. It is his seven novels, however, that have received the most critical acclaim. *Fat Woman* (1980) was shortlisted for the Governor General's Award. *Shakespeare's Dog* won the Governor General's Award in 1983. *A Good Baby* was made into a feature film. Rooke founded the Eden Mills Writers' Festival in 1989. In 2007, he was invested into the Order of Canada.

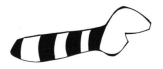